James Hall is an art historian, critic, lecturer and broad-caster, formerly chief art critic of the *Sunday Correspondent* and of *The Guardian*. He is research professor in Art History and Theory at the Winchester School of Art, University of Southampton, and a contributor to the *Art Newspaper*, the *Literary Review*, the *Burlington Magazine* and the *Times Literary Supplement*. His books include *The Sinister Side: How Left–Right Symbolism Shaped Western Art* (2008), *The Self-Portrait: A Cultural History* (2014) and *The Artist's Studio: A Cultural History* (2022), named by *The Times* as one of its Best Art Books of 2022.

POCKET PERSPECTIVES

Surprising, questioning, challenging, enriching: the Pocket Perspectives series presents timeless works by writers and thinkers who have shaped the conversation across the arts, visual culture and history. Celebrating the undiminished vitality of their ideas today, these covetable and collectable books embody the best of Thames & Hudson.

JAMES HALL
ON THE SELF-PORTRAIT

With 27 illustrations

This book consists of extracts from *The Self-Portrait: A Cultural History* by James Hall, published by Thames & Hudson in 2014.

Front cover and endpapers: Details from Artemisia Gentileschi, *Self-Portrait as the Allegory of Painting*, *c.* 1638–9. Oil on canvas, 98.6 × 75.2 cm (38⅞ × 29⅝ in.). Royal Collection Trust/His Majesty King Charles III, 2024/Bridgeman Images

First published in the United Kingdom in 2014 in *The Self-Portrait: A Cultural History* by Thames & Hudson Ltd, 181A High Holborn, London WC1V 7QX

First published in the United States of America in 2014 in *The Self-Portrait: A Cultural History* by Thames & Hudson Inc., 500 Fifth Avenue, New York, New York 10110

This abridged edition published in the United Kingdom in 2024 by Thames & Hudson Ltd, 181A High Holborn, London WC1V 7QX

This abridged edition published in the United States of America in 2024 Thames & Hudson Inc., 500 Fifth Avenue, New York, New York 10110

James Hall on The Self-Portrait
© 2024 Thames & Hudson Ltd, London
Text © 2014 James Hall

British Library Cataloguing-in-Publication Data
A catalogue record for this book is available from the British Library

Library of Congress Control Number 2023952354

ISBN 978-0-500-02727-1

Printed in China by Shenzhen Reliance Printing Co. Ltd

CONTENTS

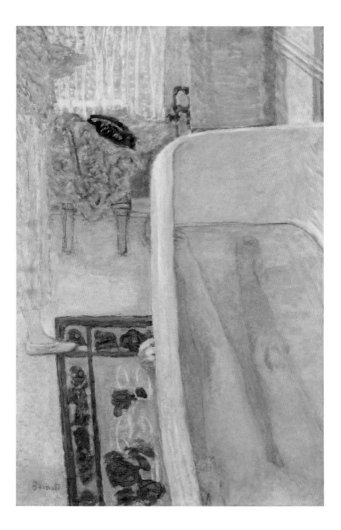

1. Pierre Bonnard, *Nude in the Bath*, 1925.
Oil on canvas.

INTRODUCTION

SELF-PORTRAITURE HAS BECOME the defining visual genre of our confessional age: the sheer volume of contemporary self-portraits defies enumeration. More of us, from more countries, are more interested in self-portraiture than ever before. Self-portraits have migrated far beyond the church, palace, studio, academy, museum, gallery, plinth and frame. Nowadays photographic and filmed self-portraits flood the internet, and smartphone selfies are ubiquitous. It is widely assumed – and hoped – that self-portraits give privileged access to the sitter's soul, and thereby overcome the alienation and anonymity experienced by so many in modern urbanized societies.

In Europe, self-portraits have been collected and venerated since the 16th century. But past interest in the genre is overshadowed by the obsession with self-portraiture during the last forty years. Today there are artists whose entire careers are forged on self-portraiture.

Exhibitions of old and modern masters are routinely prefaced by a self-portrait; Rembrandt, Reynolds, Courbet and Munch have had full exhibitions dedicated to their self-portraits. And wherever an artist has inconsiderately failed to make any, or sufficient, self-portraits, Freudian analysis fills the breach. So we find *subconscious, disguised*

and *surrogate* self-portraits: the *Mona Lisa* becomes a Leonardo self-portrait in drag. Self-portraiture is the magical Fifth Element, first among equals with the four traditional genres (histories, portraits, landscapes and still lifes). Depending on who you talk to, it is an inspiring symbol of artistic freedom or a symptom of what has been dubbed 'the culture of narcissism'. Few are indifferent to self-portraits, and the claims that are made for them.

On the Self-Portrait maps the genre from the Middle Ages to the prolific self-image-making of today's contemporary artists. Portraiture may have been pioneered by the Egyptians, Greeks and Romans, but in the Middle Ages self-portraiture becomes very much a Christian concern, connected with personal salvation, honour and love. The medieval legend of Saint Veronica, in which Christ presses his face to a piece of cloth, leaving an imprint, posited Christ as a self-portraitist. No great self-portraitist is of higher status than Saint Dunstan, prostrate on a mountain top, making himself both high and low (p. 20); and no funnier self-portrait exists than that of 1136 of Hildebertus, throwing a sponge at a mouse stealing his lunch (p. 23). Like all the best jokes, it makes a profound point.

The self-portrait – more so than a portrait – is primarily a product of memory and imagination. If naturalism had been the principal goal, it would make more sense to have a portrait painted or life cast made. In the first philosophical discussion of self-portraiture, by the influential Plotinus (AD 3rd century), self-portraits

are produced not by looking out at a mirror but by withdrawing into the self. During the Renaissance, one of the main theories of self-portraiture was the catch-phrase 'every painter paints himself': this meant that all artists unwittingly imbue all the figures they make with something of themselves, so all bear a 'family resemblance'.

One of the wonders of self-portraits is their capacity to induce unique levels of uncertainty in the viewer. Is the artist looking at us with a view to portraying or judging us? Is the artist looking at a mirror, with a view to portraying or judging themselves? Is the artist creating a persona to serve specific ends? Or have they delved into the book of memory, myth and imagination to create a work personal in its meaning?

There are bystander self-portraits, in which the artist appears as a face in the crowd or as part of a multi-figure narrative; group self-portraits, in which the artist appears with family, associates or even the Virgin Mary; and independent self-portraits, discrete images depicting only the artist. Whatever the type, the artist strives to find the perfect image, whether profile, oblique or frontal. The first 'independent' self-portrait is a fine example of this. It is a medal by the archetypal 'Renaissance man' Leon Battista Alberti, in which he depicts himself in profile. Arranged either side of his head are several examples of his personal symbol, a winged eye. It is with these shamanistic flying eyes that he sees the whole world – and that includes the back of his head and neck, his knobbly ear and severe haircut.

One of the most crucial aspects of the history of self-portraiture is understanding why and when self-portraits are made – and not made. Not all artists are 'fond' of making self-portraits, as the novelist Nathaniel Hawthorne insouciantly put it when writing about the vast Uffizi self-portrait collection in 1860. Neither do they create them at any stage in their career. They rarely say, as the famous *New Yorker* cartoon about Rembrandt had it: 'Hendrickje, I feel another self-portrait coming on. Bring in the funny hats.'

Rembrandt had in fact painted and etched more than half his eventual output of self-portraits by the time he was thirty. He hardly made any in the 1640s. Titian only started making self-portraits when he was about sixty, and his are the first 'old age' self-portraits. Prior to Titian, most artists made self-portraits when they were young and in rude health. Dürer's three independent painted self-portraits were all made before he was thirty. By the same token, Leonardo never made a self-portrait (though the search is still on), and neither did the great artist-autobiographer Benvenuto Cellini. Sculpted self-portraits pretty much disappear from view between 1600 and 1770.

The history of self-portraiture is also the history of collecting, displaying, publishing and faking self-portraits. Vasari has a central role here. The second edition of his *Lives of the Artists* (1568) featured engraved self-portraits of the artists. In most cases, self-portraits did not exist, so Vasari assumed that any person looking out of a multi-figure artwork or who looked individualized must be the artist. No self-portraits were credited to Giotto

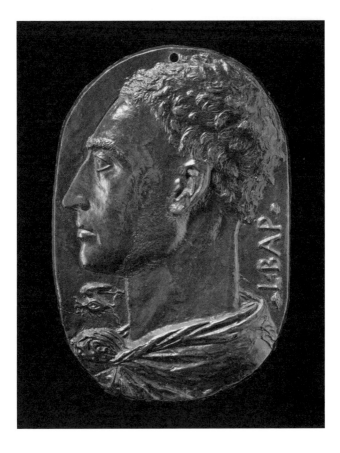

2. Leon Battista Alberti, *Self-Portrait*, *c.* 1435.
Bronze plaquette.

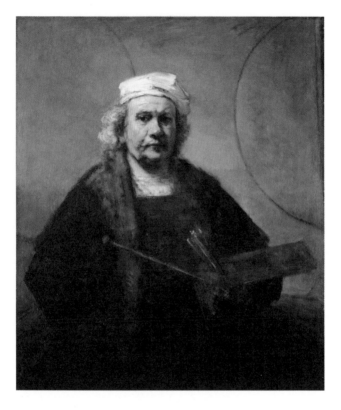

3. Rembrandt, *Self-Portrait*, *c.* 1665. Oil on canvas.

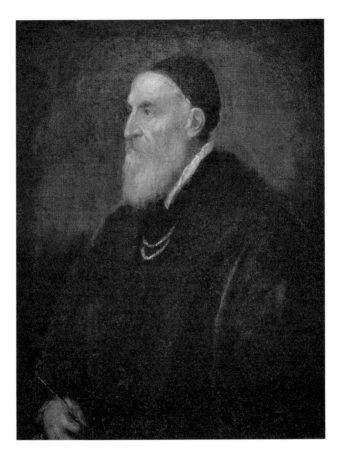

4. Titian, *Self-Portrait*, 1560s. Oil on canvas.

in the first edition; in the second edition he was credited with three. From the Romantic era onwards, there has been a gold rush of prospecting for self-portraits. More recently, there has been a countervailing tendency to demote self-portraits to portraits 'of an unknown sitter'.

When discussing self-portraiture, the modern cult of the artist makes it hard to avoid becoming overly reverential, speaking as if in hushed tones. As a result, insufficient attention has been paid to the fascinating subject of comic and caricatural self-portraits. This sub-genre takes off in the era of the Renaissance superstar artist. Just as kings demonstrate their majesty by inviting the mockery of their fools, so an artist like Michelangelo can alternate between heroic and mock-heroic self-portraits. When painting the Sistine ceiling he drew the first ever caricatural self-portrait, depicting himself in deformed action, daubing like a child. Artists were traditionally ranked at courts with 'entertainers' such as buffoons, dwarfs, wits and fools. This is how Velázquez still situates himself in his astonishing *Las Meninas*, next to but distinct from other court entertainers – dwarves, jesters, dogs – and a royal child.

Much of the best modern self-portraiture could be described as exuberantly caricatural, and in order to be so has moved decisively away from respectable head-and-shoulders self-portraiture. The body has become more important than the face. This, too, is why the history of self-portraiture has to begin properly in the Middle Ages, with Dunstan prostrate on a mountain top and Hildebertus chastising that mouse.

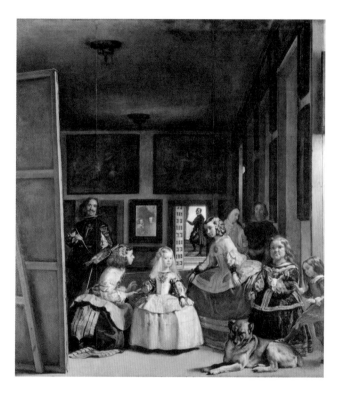

5. Diego Velázquez, *Las Meninas*, 1656. Oil on canvas.

Self-portraits have often been in the vanguard of cultural developments, influencing society's sense of identity and selfhood. There is a tendency to assume that the history of self-portraiture follows in the wake of literature, especially in relation to concepts such as 'inwardness' and 'subjectivity', which are often assumed to begin with Montaigne's semi-autobiographical essays and Descartes's 'I think therefore I am' – only later cropping up in the self-portraits of Rembrandt. Yet the influence works the other way: Montaigne and Descartes continually had recourse to metaphors taken from the visual arts to express ideas of the self and the development of consciousness. In the preface to the *Essays*, Montaigne tells us he is 'painting' his own self, and later justifies his enterprise by citing the example of the painter King René of Anjou (1409–80): 'I saw one day in Bar-le-Duc King Francis II being presented with a self-portrait by King René as a souvenir of him. Why is it not equally permissible to portray yourself with your pen as he did with his brush?'

Montaigne believed – like so many since – that self-portraits are uniquely direct, vivid, intimate and honest.

MEDIEVAL ORIGINS

BOOKS ON SELF-PORTRAITURE tend to give the Middle Ages short shrift. It is widely assumed that medieval artists were content to be anonymous dogsbodies, at worst slavishly following time-honoured conventions; at best subservient conduits for God's will. Yet it is in the Christian Middle Ages – preoccupied with personal salvation and self-scrutiny – that we see the start of a coherent tradition of self-portraiture.

The neglect of medieval self-portraiture is usually part of a larger argument that naturalistic portraiture did not exist during the Middle Ages. It is certainly true that in late antiquity the classical belief in the 'science' of physiognomy, whereby character can be read from a person's face, had been challenged by the Neoplatonic and Christian belief that the imperishable, invisible soul is the true measure of man. In art, people are often identified by attributes, scale, position and gesture rather than facial particularities (bigwigs generally being bigger, central and full frontal). You don't, as it were, put a name to a medieval face; rather, you put a name to a crown, heraldic symbol, iconographic prop or inscription.[1] Yet the artist's face is not necessarily the most interesting part of a self-portrait. The brilliance of Velázquez's *Las Meninas*

does not lie in the depiction of the painter's face (which is blankly impassive) but in the interplay of full-length figures, setting and props. The same is true of medieval self-portraits, where *mise-en-scène* is often crucial.

The loss of so much medieval art, and the accidents of survival, make it hard to generalize. But it comes as quite a shock to discover just how many medieval self-portraits do survive, and to see how imaginative, intelligent, varied and even witty they can be.

It is Plotinus (AD 204–70), the last great philosopher of antiquity and the first to treat aesthetics as a distinct field of enquiry, who sets the scene for the medieval self-portrait and its emergence as a significant genre. For Plotinus, the self-portrait is produced not by looking out at a mirror, but by withdrawing into the self. Here he uses a sculptural metaphor that would be resuscitated in the Renaissance:

> Withdraw into yourself and look. And if you do not
> find yourself beautiful yet, act as does the creator of
> a statue that is to be made beautiful: he cuts away here,
> he smoothes there, he makes this line lighter, this other
> purer, until a lovely face has grown upon his work.[2]

This visionary, process-based idea of the self-portrait, in which we sense the artist's ceaseless pursuit of perfection, both for himself and for his internalized artwork, is characteristic of the Middle Ages.

The social status of some medieval artists was extremely high – higher than at any time before or since.

Several came from the very highest echelons of society. The English church reformer, statesman, scholar and teacher Saint Dunstan (909–88) became Abbot of Glastonbury and Archbishop of Canterbury, as well as chief minister to several English kings. Wealthy and blue-blooded, he is described by his 11th-century biographer Osbern as a prodigy 'skilled in making a picture and forming letters' from childhood. Dunstan also practised metalwork and became a patron saint of English gold-smiths. By any measure, Dunstan is the most high-ranking and politically powerful artist in history.

At Glastonbury, where Dunstan rebuilt the abbey and reinstituted monastic life under a strict moral code, he painted a famous frontispiece to a Latin grammar. A wiry outline drawing, it is a pioneering example of a technique and style that would become a distinguishing feature of Anglo-Saxon art in this period. Dunstan is prostrate beside a giant standing figure of Christ. A four-line prayer is inscribed over him, the prickly lines pressing down on his flattened back like a bundle of faggots: 'I ask, merciful Christ, that you may protect me, Dunstan, and that you do not let the Taenerian storms drown me.' Taenarum was a storm-lashed coastal mountain at whose foot lay the entrance to the classical underworld.

Dunstan's 'storms' signify the worldly temptations to sin. He is humbly positioned to Christ's left, seeking absolution. Christ looks the other way, to his right (as he does in Crucifixion scenes). Yet Dunstan's proximity to Christ suggests no lack of belief in his intimacy with the redeemer, and in the likelihood of ultimate success. His

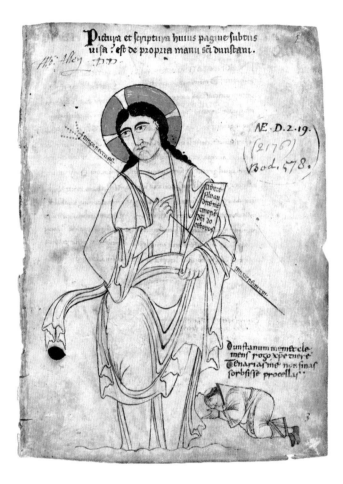

6. Saint Dunstan, *Self-Portrait Worshipping Christ*,
c. 943–57. Ink on parchment.

submissiveness is that of a courtier, for the profession of humility and even of smallness was a courtly convention. Conspicuous humility is a standard trope in medieval self-portraiture: the English monk Matthew Paris (d. 1257), who was a celebrated historian, metalworker and painter, prostrates himself beneath the throne of the Virgin and child in the frontispiece to the third volume of his *Historia Anglorum*. But his name is prominently inscribed in large letters above his back.

Mount Taenarum had been thrillingly evoked in the 1st-century AD Roman author Statius's epic poem the *Thebaid* (2: 32ff). The summit is a relatively calm place out of reach of the storm clouds and 'the vapours of the lower region', and a resting place for 'weary stars'. This is where Dunstan is positioned, on a rocky outcrop, wearied after a long penitential climb. Dunstan's Christ must be rising above those same vapours and clouds. Dunstan is not just covering his face with his hand, he is wiping off the vapours that still cling to it, trying to turn it – as advised by Plotinus – into a 'lovely face', radiant with light.

So why is a medieval churchman executing a self-portrait of great power and sophistication? A good indication is given by the most important early medieval technical treatise on the visual arts, Theophilus's *An Essay on Diverse Arts* (c. 1125). Theophilus, the pseudonym of a German goldsmith, claims the 'useful occupation' of the hands avoids sloth and distraction.[3] It is sinful not to exercise a God-given talent for making artefacts that praise the Lord, demonstrate the beauty of the divinely created world, and enable church services to be performed – so

long as it is pursued for the love of God rather than for worldly fame or money.

Dunstan would surely have agreed with all of this (apart from the use of a pseudonym), and his inscribed self-portrait is designed to bring himself forcibly to the attention of God and to all future readers of the Latin grammar. But Dunstan is making a further claim on our attention and respect. The heroic Lilliputian figure who has created this giant image of Christ is within touching distance of the divine. Thus his images and words have an unimpeachable authenticity. He is a reliable eyewitness, seeing God through both his inner and outer eye.

*

Explicit assertions of the endlessness of the artist's task occur in the 12th century, when illuminators incorporate miniaturized versions of themselves at work into the picture. We see them putting the finishing touches to an illuminated initial, or to some other important structural component, which ingeniously frames them. Some artists depict themselves in the margin, conscientiously pulling up by rope sections of text, as if it were a building block.[4] These wry, self-conscious allusions to the nitty-gritty of the artistic process would not be rivalled until the 17th and especially 20th centuries.

A different aspect of the working process is explored by the 12th-century Bohemian lay painter Hildebertus. He shows himself at work with his young assistant Everwinus (each has an identifying inscription overhead). In a celebrated full-page line drawing in the midst of a copy of Saint

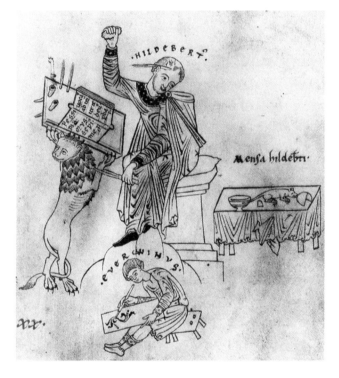

7. Hildebertus, *Self-Portrait with His Assistant Everwinus*, c. 1150. Ink on parchment.

Augustine's Christian classic *City of God*, Hildebertus sits cross-legged before a lectern desk fancifully held up by the front paws of a lion standing on its hind legs. An open book rests on the lectern, but Hildebertus is not working on it. His right arm is raised and seems to hold a rock, while he holds a quill in his lowered left hand. At first sight he could be Saint Jerome, who wrote the standard Latin version of the Bible, healed a lion (which became his symbol), and beat his breast in penance with a rock when assailed by erotic visions.

It turns out that although Hildebertus is no Saint Jerome, he is assailed by something no less troublesome. He is about to throw a sponge at a mouse scampering across his dinner table. The mouse has knocked a roast chicken over the table's edge and is heading for what must be a bread roll. They are old adversaries, as we know from a Latin text inscribed in Hildebertus's book: 'Damn you, wretched mouse exasperating me so often!' It is a parody of the Last Judgment, where Christ banishes the damned, 'Depart from Me, you cursed...' (Matthew 25:41).

Two points need to be made here. Firstly, Hildebertus is keen to show he is a master of words as well as images. There are words but no images in the book on the lectern (it almost looks as though he is filling in the bits the scribe missed). Secondly, he wants to show that he has prodigious powers of concentration and stamina. Hildebertus wishes us to believe he is only momentarily distracted, and that his 'distraction' brings enlightenment. He is addressing an issue discussed at length by Augustine in his spiritual autobiography, *The Confessions*, and one

which would preoccupy all subsequent preachers and theologians.[5] Augustine discusses the daily temptations that distract us from our higher calling. They include all manner of sensory beauty (especially women and works of art); 'greed for food and drink'; and curiosity:

> What of the many times when I am sitting at home and my attention is captured by a lizard catching flies or a spider enmeshing them as they fly heedlessly into her nets?

And yet, rather than his thought being 'blunted',

> From these sights I press on to praise you, who have wondrously created all things and set them in their due place.[6]

Hildebertus is 'distracted' by the mouse, but he would have us believe that, like Augustine, he profits from the distraction. The completed copy of Augustine's extremely long *City of God*, within which this illustration is inserted, demonstrates that no amount of interruptions or distractions could prevent the fulfilment of the task. Rather, they spur Hildebertus on, giving him a better feeling for the big picture – for the city of man and of God.

THE RENAISSANCE ARTIST AS HERO

NUREMBERG IN SOUTHERN GERMANY had grown rich on international trade throughout the 15th century, and the city council was run by merchants.[7] Unlike most other cities, there were no trade guilds, and crafts vital for the city's economic and military wellbeing were directly controlled by the council. Painting and sculpture were called the 'free arts' because there were no guild regulations determining training and conduct, or licensing artists to practise. Until 1509, foreign masters could set up shop in Nuremberg, and the more open environment does seem to have encouraged innovation and fruitful competition between artists and between patrons.

No Nuremberg artist was more commercially innovative or cosmopolitan than the printmaker and painter Albrecht Dürer (1471–1528), son of a distinguished goldsmith. He is the first non-Italian artist to become famous for his conduct and appearance – especially his hair and hands – as well as his art. Leonardo was known for his beauty, wit and elegance; Dürer used self-portraiture to immortalize himself as the northern 'artist-as-beauty'.[8]

Dürer is the most celebrated, prolific and inventive creator of self-portraits during the Renaissance.

Altogether he made some sixteen self-images – including independent drawn and painted self-portraits, and painted images of himself as a bystander in three major altarpieces. He also made studies of his hands and legs. In around 1510, he sent his own self-portrait to Raphael, and Raphael reciprocated with some drawings of his own (though not a self-portrait).

Paradoxically Dürer is not the most public of self-portraitists, for he did not make a print self-portrait. He may have felt his 'AD' monogram sufficed, and several print portraits of him were made by other artists in his lifetime. Cold commercial considerations may have played a part too: a print of the Virgin would make more money than a self-portrait. Three independent painted self-portraits of 1493, 1498 and 1500 appear to be personal milestones for they are all signed, dated and elaborately inscribed. All three show him dressed opulently and make a feature of his hair, the drawing of which is invariably a masterpiece of the calligrapher's art.

The most opulent is the self-portrait of 1498, a half-length image, in which we see him from his right side in half profile (a Flemish convention), standing before a window with a view of a verdant landscape. It was painted in Nuremberg while Dürer was working on a series of fifteen woodcuts of the Apocalypse, or 'The Revelation of John the Divine'. This was the first book to be both published and illustrated by an artist, though some images were sold individually as loose sheets. These dramatic full-page images, timed to fuel and exploit the religious fervour connected with the

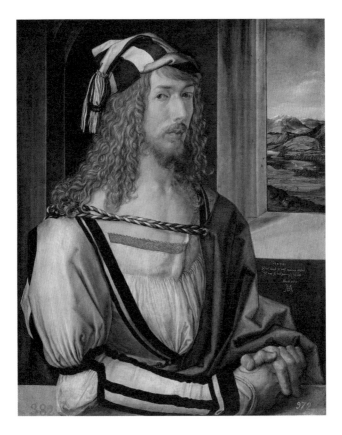

8. Albrecht Dürer, *Self-Portrait*, 1498. Oil on panel.

imminent half-millennium and the supposed second coming of Christ, made Dürer famous throughout Europe. Yet he presents himself in the self-portrait as someone who has never felt fear, let alone apocalyptic fear. He must have been aware of the irony. He could easily be one of the sumptuously dressed male clients in his own *Apocalypse* print of *The Whore of Babylon*. The only pain this man might have experienced is the pressure of being a living work of art.

Dürer initially trained to be a goldsmith, and this goldsmith manqué is pure gold. Golden hair with coiffured corkscrew curls, all painted with the finest of brushes, tumbles down golden skin. He sports an elegant moustache and beard. The faces in Dürer's painted portraits rarely look animated, and this one is no exception. Just below the window ledge we find inscribed in calligraphic letters: 'In 1498 I painted this from my own form. I was twenty-six years old. Albrecht Dürer'.

It is usually assumed that Dürer is presenting himself here as an Italian-style *gentiluomo* (gentleman), and his letters home from Venice during his second stay there in 1505–7 are often used as virtual speech bubbles for the picture. The letters were sent to his friend Willibald Pirckheimer, on whose behalf Dürer acquired luxury textiles, jewelry, feathers, etc. Dürer wrote: 'What do you mean by setting me to such dirty work [buying rings]? I have become a gentleman at Venice'; 'My French mantle, my doublet, and my brown coat send you a hearty greeting'; 'How I shall freeze after this [Venetian] sun. Here I am a gentleman, at home only a parasite.'[9]

But he also complains about Venetian artists who steal his ideas and copy his works; and he says he is so thronged by friendly Italian artists 'that at times I have to shut myself up'.[10] There is already a sense in this self-portrait of him being protectively yet constrictingly shut away, like a reliquary in a cathedral treasury. Through the window we glimpse an alpine landscape with a distant snow-capped mountain, which picks up the white stripes on his tasselled cap: the visual echo emphasizes his indomitable remoteness. His gaze is sly, suspicious. Petrarch called his own autobiography 'My Secret' because he claimed to want to keep its contents private and there is something grandly secretive about Dürer's self-portrait.

The intensely hieratic and sombre self-portrait of 1500 is more the kind of thing we might imagine being made by the creator of the *Apocalypse* series. It is a half-length, full-frontal image, placed against a black background with darker brown hair and skin to match Dürer's brown coat. The principal break in the painting's symmetry is the artist's portentously raised right hand, the fingertips placed in front of his breastbone. Since the mid-19th century, this format has frequently been compared to images of Christ. By making the visual analogy (and the darkness alludes to it too), Dürer implies he is a Christ-like figure, with divine powers of creation. In his later treatise on proportion, Dürer would claim that God 'grants great power unto artistic men'.[11]

That said, Dürer is much too well turned out to be an exact counterpart to Christ. His permed hair, plucked eyebrows, waxed handlebar moustache and trimmed

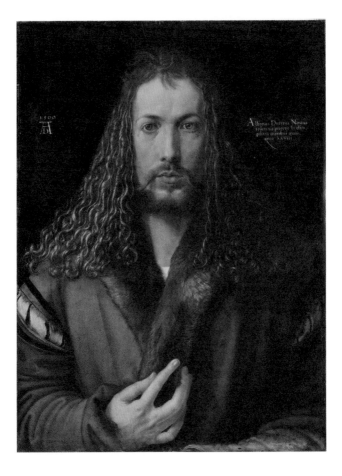

9. Albrecht Dürer, *Self-Portrait*, 1500. Oil on panel.

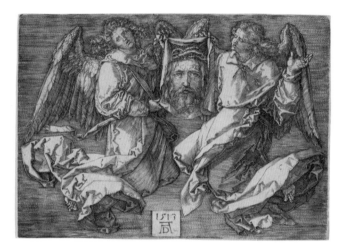

10. Albrecht Dürer, *Sudarium of St Veronica;*
two angels holding the cloth depicting the face
of Christ, 1513. Engraving.

beard are a tour de force of the barber's art. Indeed, hair has surely never been so intricately and painstakingly painted. If we compare the self-portrait with Dürer's engraving of 1513 showing Veronica's veil held by two angels, the artist's cascading curly hair is much closer to that of the angels than of Christ, which is understandably rather dishevelled. Indeed, no image of Christ by Dürer has such finely wrought hair. The closest comparisons are with the hair of Dürer's women and the fur of his animals.

Dürer's hair was famous among his contemporaries, and after his death in 1528 his admirers exhumed his body to take casts of his face and hands, and cut lockets of hair. In the self-portrait of 1500, individual strands are depicted with filigree fineness and the colours range from precious gold and silver to brown and black. At the central parting, a long lock of hair has been looped and tied in a circle. His clothes are luxury items lovingly delineated.

This self-portrait is meant to be the last word in the artist as beauty. And that beauty is meant to live forever. The inscriptions on the painting, placed either side of the artist's eyes, emphasize this. The more laconic one on Dürer's right – the date 1500, above Dürer's AD logo, here making a pun on Anno Domini – prompts thoughts about eschatological time and the second coming of Christ; the chattier, more localized inscription to Dürer's left – 'I, Albrecht Dürer of Nuremberg painted myself thus, with undying colour, at the age of twenty-eight years' – suggests the picture will never fade.

Initially the painting's reception seems to have been enthusiastic. Conrad Celtis, the German poet laureate,

had written an epigram about it by the end of 1500.[12] At an unknown date it was put on display in Nuremberg's town hall alongside sculpted and painted portraits of the great and good, which had populated the building ever since its construction in 1332–4.[13] It is probably the first portable self-portrait to be publicly displayed.

Nonetheless, it had no significant artistic progeny until the 19th century. Whereas his other painted self-portraits in half profile from two altarpieces were reproduced in the 17th century, it was not until 1811 that a reproductive print seems to have appeared. Goethe later described the face of Christ in a 15th-century German painting of Saint Veronica as 'frightening, Medusa-like',[14] and Dürer's self-portrait may have inspired similar feelings. Its static, hieratic format may have looked crude and its austere opulence almost medieval in the era of Titian and van Dyck.

THE ARTIST AT WORK

BY THE 17TH CENTURY, studio visits were fashionable for anyone who considered themselves a gentleman. No wonder, then, if some of the greatest of 17th-century self-portraits depict the artist at work.[15] Strictly speaking, this represents a revival of medieval conventions, but whereas in most medieval depictions the artist is at work 'on site', in the 17th century the artist's studio itself is the 'destination', an exotic site of pilgrimage and entertainment. Much of the interest of these self-portraits stems from the ways in which artists negotiate the spatial and conceptual limitations of the studio: the banality of the workshop situation, and even its intimacy and domesticity, has to be balanced by a sense of sacredness and the artist's contemplative aloofness.

One of the finest 'artist-at-work' pictures was painted by Artemisia Gentileschi (1593–after 1653). Like her Italian precursors Sofonisba Anguissola and Lavinia Fontana, she made several self-portraits but few of these have survived or been convincingly identified (they are cited in letters and inventories). Artemisia specialized in female heroines and the female nude, and there has been a tendency to assume that at some level she always 'painted herself', even if the physiognomies of her heroines are

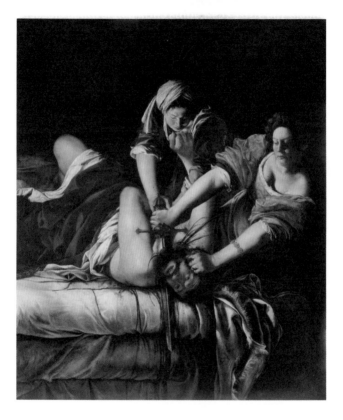

11. Artemisia Gentileschi, *Judith Slaying Holofernes*, c. 1612–13. Oil on canvas.

differentiated. Because she was raped by a collaborator of her painter father who was subsequently tried and convicted, her many depictions of Judith, killer of Holofernes, have been interpreted as self-portraits.

A purely biographical interpretation is probably anachronistic, however. Her idiom is resolutely heroic and non-domestic, her scale monumental. Judith was a popular subject, painted on several occasions by her father Orazio, who taught her how to paint, and it is debatable if her Judiths refer to her feelings about the rape (Holofernes never touches Judith).[16] The 1630s would see the emergence of a cult of the strong woman, promoted by Queen Marie de' Medici of France and her daughter-in-law Anne of Austria.[17] Artemisia depicted herself as an Amazon in a lost painting for Cosimo II de' Medici, and in 1649 promised a patron: 'You will find the spirit of Caesar in this soul of a woman.'[18] She was famous in her own lifetime and this generated demand for self-portraits and portraits.

Self-Portrait as the Allegory of Painting (*c.* 1638–9) was probably painted for Charles I when Artemisia was visiting her father in London. Orazio was court painter to Henrietta, Queen of England. In the catalogue of Charles I's collection, compiled after his execution in 1649, it is listed with another self-portrait which has been lost.[19]

Guessing the hand and style of different artists was a popular pastime at the Stuart court,[20] and the King had a particular and well-known interest in self-portraits. He commissioned self-portraits of his court painters, Daniel Mytens, Rubens and van Dyck, which were hung

in the intimacy of the breakfast chamber. His love of Italian painting was reflected in self-portraits by Titian, Pordenone, Bronzino and Giulio Romano, hung in the Long Gallery at Whitehall. He was given a Rembrandt self-portrait (1630–1) by the Earl of Ancram; Dürer's self-portrait (1498) and the so-called *Portrait of Dürer's Father* (1497) were a gift from the city council of Nuremberg.[21] The sheer chutzpah of Artemisia's picture – she is both sexy and awesome, near and far – would in part be due to the fact that it had to compete with so many rival self-portraits by famous male artists.

Artemisia's picture – generally, though not universally, accepted as a self-portrait – is the most forceful affirmation of artistic genius that had yet been painted. It is based in part on the description of Pittura (Painting) in Cesare Ripa's iconographic handbook *Iconologia* (first edition 1593), which became a bible to many 17th-century painters. It was designed to increase the intellectual content and legibility of art. Ripa describes Pittura as: 'A beautiful woman, with full black hair, dishevelled, and twisted in various ways, with arched eyebrows that show imaginative thought...with a chain of gold at her throat from which hangs a mask, and has written in front "imitation". She holds in her hand a brush, and in the other the palette, with clothes of evanescently coloured drapery....'[22] Ripa envisages Pittura as a full-length figure, her robes extending to her feet, where painter's tools and instruments are scattered on the ground, but the lower body of Artemisia's Pittura is elided and there is no sense that she is even fixed to the ground.

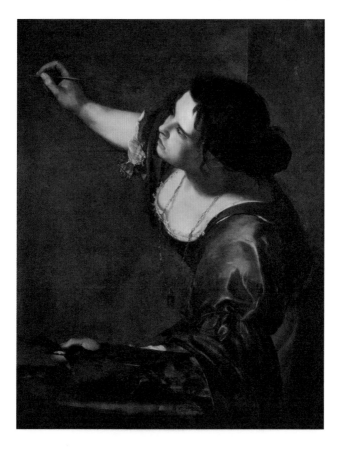

12. Artemisia Gentileschi, *Self-Portrait as the Allegory of Painting*, *c*. 1638–9. Oil on canvas.

Artemisia's eyebrows are not arched – but her arms and back are. No one since the Middle Ages had shown painting to be such an intensely physical activity – except for Michelangelo in his tiny caricature, bent like a Syrian bow. Her outstretched right hand looks as though it is dusted with charcoal; she sensibly wears a brown apron over her green dress. She leans her left forearm, which bears the palette and spare brushes, on a small table (its corner marked with A. G. F. – 'F' for *fecit*, made it). But we scarcely notice that she is supported at all. Her body below the waist merges with the dark background and her hero-ically scaled and foreshortened upper body seems to float towards the light, which powerfully strikes her forehead and breast. The background – a mass of scumbled browns and blacks – seems almost inchoate and immaterial. It has been variously interpreted as a blank canvas and as a wall.

So where are we and what is going on? The cult of Michelangelo, as much as Ripa, is the key to our under-standing of the London self-portrait. In 1612, Artemisia had married a Florentine and moved to his home city. Orazio had recommended her as 'without equal' to the Grand Duchess Cristina, and from then on she enjoyed Medici patronage and protection. In 1616 Artemisia became the first woman artist to join the Accademia del Disegno in Florence, and in 1615–17 she contributed an *Allegory of Natural Talent* to the decorations glorify-ing Michelangelo in Casa Buonarroti. Commissioned by his great-nephew and namesake, Michelangelo the Younger, it consisted of a scantily clad woman holding a compass – the iconography, once again, taken from Ripa.

No compass will help us map the later self-portrait, for Artemisia is creating something out of nothing. Her open-armed pose and monumental scale and her floating foreshortened torso are modelled on the creating God of the Sistine ceiling – especially God separating light and darkness. It is a breathtakingly bold double appropriation of Michelangelo and of the 'God-as-painter' idea. To this end, the brown background is not clearly identified as a blank canvas, and it is parallel to the picture plane: it would have to be angled into the room for her to feasibly paint it. She seems to be reaching across and beyond it, towards the powerful light. Artemisia is posited as an artist who works directly with light, and for whom the sky is the limit. A grotesque mask hangs on a chain around her neck – as recommended by Ripa – but it is not inscribed 'imitation', for she is a creator *ex nihilo*, out of nothing.

Artemisia may have assisted her father with oil-on-canvas ceiling paintings for the Queen's House in Greenwich (1638–9), which included an *Allegory of the Arts under the English Crown*. Her self-portrait could easily be displayed on a ceiling: it could be rotated and shown any way up.[23] It is gravity-defying, and it articulates a frustration with the limitations of small-scale easel painting: it challenges the cult of the studio as much as it contributes to it. As Artemisia was a woman, she was never able to get commissions for frescoes and large-scale decorative schemes like the Greenwich ceiling. So the self-portrait – a 'mere' 96.5 by 73.7 cm (*c*. 38 by 29 in.) – gestures towards something much larger, and is full of yearning. Yet her gender is not the only

reason for her confinement to easel painting. This was increasingly the age of the subject specialist and the gallery picture. There is nostalgia for a more heroic age not just in Artemisia's specialism in ancient heroines, but in her emulation of Michelangelo.

When Artemisia was working in Florence for Michelangelo the Younger, he was preparing the first edition of his great ancestor's poetry. One hundred poems were eventually published in 1623 – with the language smoothed out and the gender of the addressee changed, where necessary, from male to female. One can only wonder if he showed her the madrigal written for Vittoria Colonna which begins: 'A man in a woman, indeed a god speaks through her mouth....'[24]

COMING HOME: INTO THE 19TH CENTURY

FEW ARTISTS WENT to greater lengths to root themselves in primordial soil than the Dutch artist Vincent van Gogh (1853–90). From very early on, he aspired to be a peasant painter, living and recording the life of a peasant with religious fervour. He even collected the clothes of peasants and labourers.

He identified with the more sentimental and heroizing peasant painter Jean-François Millet. In 1885, he went to live in the rural village of Nuenen, and while there he wrote: 'I've never seen the house where Millet lived – but I imagine these 4 little human nests [pictures of cottages] are of the same kind.'[25] He praised the intense look of a Millet self-portrait in charcoal wearing 'a kind of shepherd's cap on top'[26] and agreed with a critic's remark that Millet's *Sower* seems 'painted with the soil he sows'.[27] Even from the asylum in Saint-Rémy, he would write to his mother – in reference to his thick impastos – 'I plough on my canvases as they do in their fields'.[28]

Van Gogh's first major bout of self-portraiture occurred when he lived in Paris from 1886–8. He painted himself over twenty times, gradually adopting the high-keyed palette and dabbed brushstrokes of Neo-Impressionism.

He was determined to use portraiture as a vehicle for self-expression – which he believed to be totally lacking in his *bête noire*, portrait photography: 'painted portraits have a life of their own that comes from deep in the soul of the painter and where the machine can't go'.[29]

Painting himself saved money – he did not have to pay the model[30] – but it also helped anchor him in a fast-moving cosmopolitan world of artists and art galleries. He touched base, as it were, with his first darkly brooding self-portrait, inspired by Rembrandt's *Self-Portrait at the Easel* (1660) in the Louvre. Rembrandt had become *the* great exemplar of the down-to-earth, home-loving old master. He had apparently never travelled abroad, and preferred fraternizing with beggars rather than princes.

Rembrandt bookended Van Gogh's Paris stay, for his last and most impressive self-portrait, *Self-Portrait at the Easel*, was inspired by the same Louvre self-portrait.[31] But now the painter stares blindly at the canvas with black-green eyes, a frozen zombified version of a hieratic Neoclassical bust. He looks literally petrified amid the splintery craquelure of brushstrokes and the icy-white shimmer of the background. In Carel Vosmaer's *Rembrandt* (1877), the first major biography, geniuses are said to be as 'isolated, colossal, and sometimes also as bizarre and enigmatic' as sphinxes in the desert, or Celtic menhirs.[32] Van Gogh strives for this sort of menhir-like immovability.

On a more down-to-earth level, the picture was painted in January 1888, and he could not afford much

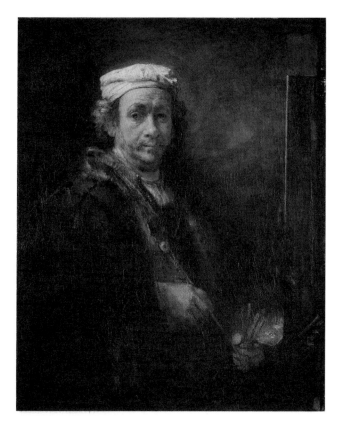

13. Rembrandt, *Self-Portrait at the Easel*, 1660.
Oil on canvas.

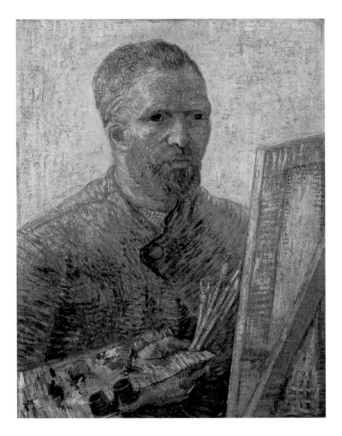

14. Vincent van Gogh, *Self-Portrait at the Easel*, winter 1887–8. Oil on canvas.

heating. So it is also the first *frozen* self-portrait. But he is petrified less by his own circumstances than by his own genius – by the Medusa stare of his own sensational picture. He told his sister that it was much more profound than any portrait photograph.

Van Gogh went to the southern rural backwater of Arles to realize his dream of becoming a peasant painter, and with the hope of enticing like-minded artists to form an artists' colony. Having rented the four-room Yellow House and set up a studio there, he invited Paul Gauguin (1848–1903) to join him. They had met in Paris, but Gauguin was then in Pont-Aven, a favoured haunt of artists on the Brittany coast. Gauguin agreed, and Van Gogh set about making what he called a 'Studio of the South', decorating it with pictures of 'connected and complementary subjects'. This was now the age of the 'house beautiful', where each object was carefully chosen to create harmony and to advertise the unique sensibility of the owner. Van Gogh's Yellow House is a budget version of William Morris's Red House, built for him by Philip Webb in 1859–60.

Van Gogh hung Japanese prints (the height of avant-garde fashion) and decided to put his sunflower paintings in Gauguin's room. Sunflowers were the favourite decorative motif of aesthetes: a *Punch* cartoon of 1881 depicted Oscar Wilde as a sunflower, with the caption: 'O, I feel just as happy as a bright Sunflower!'[33] Van Gogh bought twelve traditional rush-bottomed chairs in the mistaken belief that there were twelve members of the Pre-Raphaelite brotherhood. He bought two beds and planned to paint

his own with a naked woman and a baby in a cradle;[34] over it hung two portraits of male friends, a poet and a soldier, to represent his artistic and sexual side. He also painted pictures of the Yellow House, inside and out, and of the neighbourhood, including the café and a nearby garden.

He envisaged it as a quasi-monastic retreat, a church for the religion of the future, with Gauguin as abbot. It was also to be a museum filled with self-portraits and with portraits of artists, friends and local people. He was sending his pictures to his art-dealer brother Theo in Paris, but if he particularly liked a work, he made a copy to keep. He wanted to track his own development, not send his favourite offspring away and become alienated from his art. He approved of the increasing tendency for dealers to mount solo shows, or group shows of like-minded artists.[35] Édouard Manet had started the trend when he exhibited fourteen works at a Parisian dealer in 1863,[36] and there were eight Impressionist group exhibitions from 1874–86.

As a youth, Van Gogh had copied out texts by German Romantics into albums to be given as gifts to friends, and he was full of their idealism. The German Nazarenes in Rome in 1808 pioneered the idea of an artists' brotherhood, based on a sentimental belief in medieval piety and solidarity, and they in turn influenced the English Pre-Raphaelites. Their inspiration was Wilhelm Wackenroder's *Confessions from the Heart of an Art-Loving Friar* (1796), published anonymously when he was a lawyer of twenty-three. The fictional friar preaches universal harmony in which temporal, physical and individual 'antipodes' are brought together into a variegated and

pleasing whole. The centrepiece is a paean to Dürer, in which the friar visits Nuremberg and sees the neglected cemetery, made beautiful by tall sunflowers that 'spring up in multitudes', and Dürer's 'forgotten bones'.

Two great 'antipodes' – Dürer and Raphael – are brought together in a dream. The friar dreams he visits a gallery of Old Masters after midnight, and finds it 'illuminated by a strange light' and all the artists standing in front of their own pictures. He is told they descend from heaven every night to look at 'the still beloved pictures [painted] by their own hands'. Apart from the others, he sees Dürer and Raphael standing hand in hand 'silently gazing in friendly tranquillity at their paintings, hanging side by side'. He is just about to greet 'my Albrecht and pour out my love', when he wakes. Only after the dream does he read in Vasari that Dürer and Raphael were friends 'through their works' – a reference to their exchange of drawings.[37] The art-loving monk is really an artist-loving monk, for he describes artists rather than artworks. The artist *is* their art, and always stands in front of it. Van Gogh clearly had a similar meeting of 'antipodes' in mind with 'abbot' Gauguin. It resulted in what may be the first multiple exchange of self-portraits.

When Gauguin delayed his arrival, ostensibly due to lack of money for the train fare, Van Gogh suggested he and his painter friend in Pont-Aven, Émile Bernard, send portraits of each other. In the end, they sent painted self-portraits, with portrait drawings of the other artist shown pinned to the background wall. Gauguin's output of self-portraits had been meagre before his association

with Van Gogh; but it now rocketed. A further exchange of self-portraits was made with Gauguin's painter friend Charles Laval, whose gift Van Gogh considered 'very assured'.[38] He also hoped to do an exchange with the leading Neo-Impressionist, the short-lived Georges Seurat,[39] but hoped in vain (Seurat obliterated his one attempt at a self-portrait, inserted into a portrait of his mistress). In a letter to Bernard, Van Gogh even proposed an exchange with an artist whose name he could not remember – 'the other one'.[40]

Gauguin arrived in October 1888, and in November Van Gogh painted a novel kind of paired self-portrait and portrait, depicting his own rush-bottom chair and Gauguin's armchair in two pictures. He plays with traditional gender associations. The set-up, with the chairs angled inwards, apes Renaissance paired portraits of husbands and wives, where they are turned in on each other. But while Van Gogh situates his own chair on the male 'dexter' side (our left) in bright daylight, he gives himself the armless 'lady's' chair. Gauguin gets the 'gentleman's' armchair, albeit a very curvaceous one, in a room lit by lamp and candlelight. This gender-bending was a key component of their relationship. Van Gogh had wanted Gauguin's room to be 'as nice as possible, like a woman's boudoir, really artistic',[41] and Gauguin had depicted himself against a 'girlish' background of flowery wallpaper – a symbol of purity.

The inspiration for a 'chair' portrait has been linked to Luke Fildes's *The Empty Chair* (1870), a lithographic tribute to Charles Dickens, published in *The Graphic*

after his death. Van Gogh had a copy of the print, and he idealized the magazine's illustrators as a brotherhood.[42] The position and type of chair in Fildes's image is very close to Gauguin's chair and Van Gogh has even placed a lighted candle on the seat, as if in memory of his friend. Already there were strains in their relationship, and the image is full of foreboding and fear (a novel is precariously balanced on the seat edge).

By contrast, Van Gogh's chair self-portrait seems full of optimism, brightly sunlit and with two sprouting onions poking up healthily out of a crate in the background that is inscribed 'Vincent'. The shoots resemble cuckold's horns, as though Van Gogh is making a jaunty joke about Gauguin's lack of faithfulness. It is his most enchanting self-portrait.

The day before Gauguin was due to leave Arles in December 1888, Van Gogh had a breakdown during which he first threatened Gauguin with a razor, and later that same night he cut off part of his left ear, giving the severed portion to a prostitute. This harrowing incident was memorialized yet transcended in two self-portraits with bandaged ear of January 1889. The bandages are held in place by a fur hat that 'normalizes' them, transforming them into ear flaps protecting him from the winter cold. Van Gogh was admitted to the Saint-Paul Asylum in Saint-Rémy in May 1889, and in September wrote to Theo: 'People say...that it's difficult to know oneself – but it's not easy to paint oneself either. Thus I'm working on two portraits of myself at the moment – for want of another model.... One I began the first day I got up, I was thin, pale

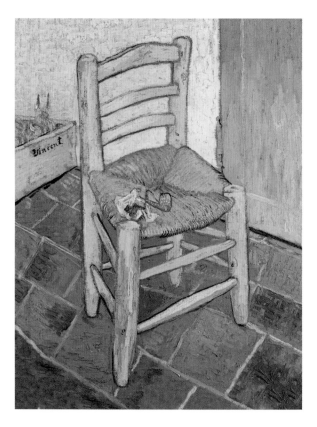

15. Vincent van Gogh, *Van Gogh's Chair*, 1888.
Oil on canvas.

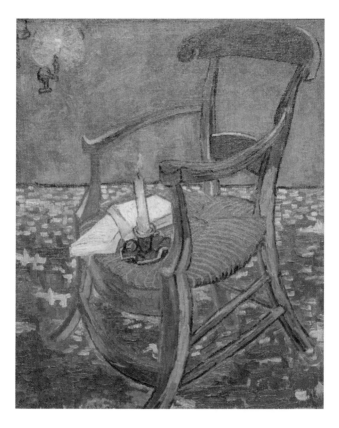

16. Vincent van Gogh, *Gauguin's Chair*, 1888.
Oil on canvas.

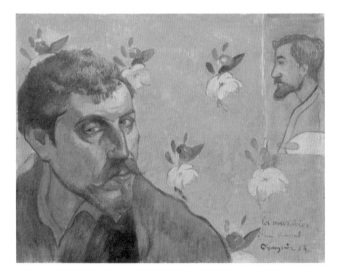

17. Paul Gauguin, *Self-Portrait with Portrait
of Émile Bernard*, 1888. Oil on canvas.

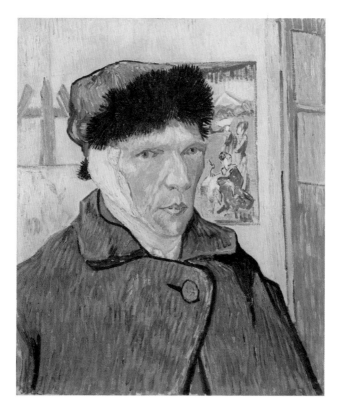

18. Vincent van Gogh, *Self-Portrait with Bandaged Ear*, 1889. Oil on canvas.

as a devil. It's dark violet blue and the head whiteish with yellow hair.... But since then I've started another one, three-quarter length on a light background.'[43]

Van Gogh pioneered the painting of simultaneous self-portraits. But it is not a celebration of the luxuriant superabundance of an artist's feelings and moods – it is an index of estrangement, of a catastrophic loss of control.

SEX AND GENIUS

THE ROLE OF WOMEN – and sex – in a male artist's life became a controversial issue in the 19th century, and generated some extraordinary self-portraits. The beginnings of female emancipation – with more middle-class women working and studying art – gave a disconcerting new twist to the relationship between male artists and female models.

For the male artist, did women, whether wives or mistresses, foster genius, or impair it? Such questions owed much to social anxieties brought about by the Industrial Revolution, and by the massive shifting populations drawn to cities. Chilling attempts were made to identify social types, all the better to control them, and the artist was one of the most interesting categories, both because of their supposed originality, and their exposure to female models. The debate centred on the relationship between art, genius and sex. The issue was whether aspiring geniuses should be having sex at all.

Vasari had already claimed that Raphael had died young as a result of his debaucheries, and that his art had declined as a result; and that Andrea del Sarto's excessive love for his wife, whose features he used for all the women in his paintings, had been to the detriment of his career.

The notion that genius was incompatible with sexual excess was given a pseudoscientific grounding by the influential Italian criminologist Cesare Lombroso, who believed genius was a form of epilepsy.

The bachelor Goncourt brothers gave their repudiation of woman a precise historical basis. Since the French Revolution, society had become so fragmented that modern man could no longer relate to modern woman: 'For our generation, art collecting is only the index of how women no longer possess the male imagination.'[44] They are referring here to what would become known as the *femme nouvelle* (new woman), who had often left the family home to enter the world of work, relocating to metropolises like Paris. Women's right to divorce was established in France in 1884. The alienated male artist and art collector sought refuge in his art.

But the consequences of art-object fetishism could be suicidal madness rather than genius. Claude Lantier, the painter hero of Émile Zola's novel *L'Œuvre* ('The work', 1886), slaves away for years on his masterpiece, a large female nude. His wife is horrified to realize her husband only loves 'this strange, nondescript monster on the canvas'. He eventually hangs himself behind the picture.

In the 20th century, Marcel Duchamp would be fascinated by the idea that modern man was alienated from woman, and thereby forced to be a bachelor. The inability of the male to achieve coition with the female was the main subject of *The Bride Stripped Bare by Her Bachelors, Even* (1915–23), better known as *The Large Glass*. The 'bachelors' in the bottom half are unable to ignite the

'love gasoline' of the bride in the top half, and they are forced to 'grind their own chocolate'.

All these ideas inspired new kinds of 'marriage self-portrait' unprecedented both in their excruciating levels of intimacy and in their sheer quantity. It is never clear whether the partner/wife is a fertilizing muse or vampiric nemesis. The trend culminates in the 1920s and 30s with Pierre Bonnard's pictures of his untouchable wife Marthe, embalmed in the bath.

The Norwegian painter and printmaker Edvard Munch (1863–1944) is one of the most prolific self-portraitists: if we include probable self-portraits in subject pictures, there are over seventy paintings, over a hundred drawings and watercolours, fifty-seven photographs and twenty prints. More exhibitions of his self-portraits have been mounted than for any other artist. Most were produced after 1902, the year in which Munch split up from the rich heiress Tulla Larsen, with whom he had had a stormy on-off relationship since 1898. He shot himself in the left hand at the final parting, having refused to marry her. He wrote to her explaining that 'my art is my greatest love'.

In four severely frontal and hieratic self-portraits of the 1890s, Munch places a female symbol directly over his head.[45] He is not just dominated by them, but a part of them. So in the watercolour *Salome-Paraphrase* (1894–8), Salome is 'paraphrased' into a waterfall of dark hair, cascading down the blood-red page but curving in at the bottom to caress and hold Munch's jug-eared moustachioed head, which sports a skew-whiff miffed expression. This Salome is not just decapitating

Munch, she is giving birth to him. Her hair is a 'para-phrase' of the female genitalia, and Munch is being born head first. To use Samuel Beckett's phrase, he is born astride the grave, but this is also a rebirth, with Munch cast as a primordial being, situated in the very spot where life is created. *Salome-Paraphrase* represents the ultimate homecoming.

After the end of his relationship with Larsen, Munch makes himself appear increasingly androgynous and hermaphroditic. Androgyny was a Symbolist ideal, an emblem of pure self-sufficiency. Gauguin had imagined himself as supremely androgynous in his self-portrait for Van Gogh with male and female qualities; Aubrey Beardsley depicted himself as a woman lurking below a big-breasted satyress in *Portrait of Himself in Bed* (1894); and from 1920–41, Duchamp had an alter ego, Rrose Sélavy: he signed works in her name and dressed in women's clothing.[46]

Munch feminizes his body, but only below the neck. In *Self-Portrait in Hell* (1903) he stands, a naked Frankenstein's monster, before a flaming, cave-like land-scape. His own jug-eared head – a peeling mask of burning red and orange – is placed on top of a golden girlish body with budding breasts. The 'join' is marked by a red slash across the neck. Munch regularly treats his head as dis-tinct from his body, and it always looks out of sorts.

Munch had a considerable influence on the Prussian-born pioneer of Expressionism Lovis Corinth (1858–1925), who was equally haunted by the relationship between sex, debauchery and genius. Corinth was to become the

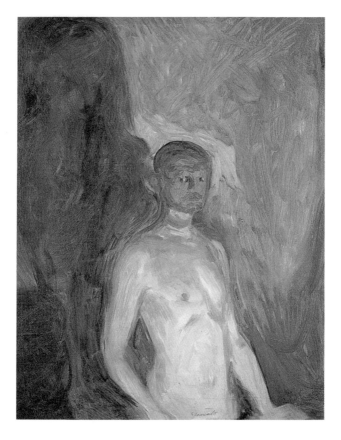

19. Edvard Munch, *Self-Portrait in Hell*, 1903.
Oil on canvas.

most systematic 'tracker' self-portraitist of the early 20th century. He painted forty-two self-portraits, after 1900 painting one on each birthday. He made over thirty self-portrait prints, and many drawings. His autobiography, begun in 1906 and published posthumously in 1926, is illustrated by thirty self-portraits.

Corinth's finest works are a series of self-portraits with his much younger wife Charlotte Berend, an art student he met in 1901 when she was twenty-one. By all accounts – including her own – her deft sense of humour and tact defused Corinth's dark nights of the soul. He eventually painted forty-one pictures of her and included her in twenty-nine genre scenes, producing a uniquely extensive and intimate record of their partnership.[47] Some of these pictures are uncomfortably ludicrous. In *The Artist and His Family* (1909), Charlotte sits serenely in the studio with their jolly baby, with Corinth standing behind, seemingly about to strike her over the head with his palette.

The finest self-portrait was painted three months after his marriage. A naked Charlotte, seen from the back, clings to the clothed Corinth, who is seen from the front, one hand resting on his heart, her head and the other arm resting on his shoulder. He stands to attention, bolt upright, eyes front, both arms raised and bent in a 'wing' position, holding paint brushes and palette. His role is usually described as protective, but this must be a moment when the future of his art and life hangs in the balance. Charlotte is preventing him from painting, even if only momentarily. In Henrik Ibsen's last play, *When We Dead*

Awaken (1899), the sculptor Professor Rubek believes if he touches his model, or even desires her sensually, his artistic vision will be lost. Corinth tries not to touch or even look at Charlotte; but she is already too close for comfort.

The ominous, even overwhelming, presence of women in the work of both Munch and Corinth attests to male anxieties about changes in the status of women – changes that extended to art education as well. Women had been admitted to official and private art schools during the second half of the 19th century: Charlotte Berend was the first student to enrol at Corinth's private art school, and she exhibited her paintings and prints from 1906. But it is a German contemporary of Berend, Paula Becker (1876–1907), who would produce a new kind of self-portrait that turns the tables on male 'bachelor' artists, and instead parades female self-sufficiency and (pro)creative genius.

In the 1890s Becker enrolled at several art schools, and in 1898 went to live in an artists' colony in Worpswede, a farming village, where she met the painter Otto Modersohn whom she would marry in 1901, changing her surname to Modersohn-Becker. In 1899 she made the first of several extended visits to Paris, usually leaving Otto behind, and her art was increasingly influenced by Cézanne, Gauguin and Van Gogh. In 1906 she went alone to Paris and seems to have had an identity and marriage crisis. Six days earlier she wrote to her friend the poet Rainer Maria Rilke: 'And now I do not know how to sign my name. I am not Modersohn, neither am I Paula Becker any more. I am myself, and I hope to become myself more and more. This

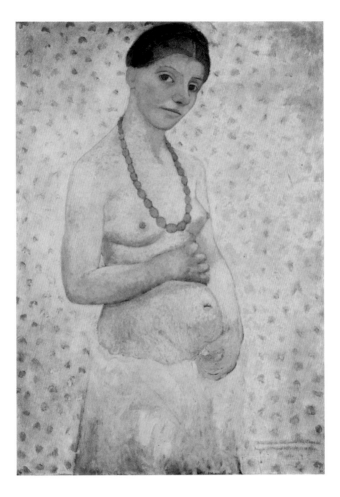

20. Paula Modersohn-Becker, *Self-Portrait*,
1906. Oil on card.

is probably the final goal of all our struggles.'[48] Becker had always been a dedicated self-portraitist, usually depicting herself alone, outstaring us with a hieratic glare – and in one case with Munch's jug ears.

Shortly after her arrival in Paris, she wrote to Otto saying that she did not want to have his child. She immediately painted her largest, life-size self-portrait, inscribed Dürer-style: 'This I painted at the age of 30 on my sixth wedding anniversary P. B.' She stands before us, faintly smiling, naked down to the waist (except for an amber-orange necklace), her hands placed above and below a belly that looks very pregnant.

The picture, with its mottled green background, has given rise to all kinds of speculation, but the pose, the simplified contours and almond-eyed physiognomy, the tied-back hair, all evoke Raphael's famous portrait *La Fornarina* (1518–19). Whereas that picture proclaimed the great artist's ownership of his model (he signed her armband), Becker's self-portrait implies that this model is self-creating and indeed self-reproducing. A perfect title for it would be Browning's line 'Why do I need you?' – now addressed to her husband and the world at large. The marriage soon resumed, however, and Modersohn-Becker tragically died three weeks after giving birth to a daughter in November 1907.

The French painter Pierre Bonnard (1867–1947) was perhaps the most home- and family-fixated artist who ever lived. During the 1890s he painted over fifty pictures of his family in his parents' country home, in window-less interiors with the doors firmly shut. In 1893, he met

Marthe de Méligny (1869–1942), who became his model and mistress, and whom he married in 1925. She would eventually appear in around 384 paintings, almost always in interiors, often nude and – after their marriage – soaking in the bath. 'I have all my subjects to hand,' he said.[49]

Bonnard painted about twelve self-portraits, and drew several more. The independent self-portraits are generally bust-length, small-scale claustrophobic close-ups, all but one painted after meeting Marthe.[50] The only one painted pre-Marthe shows him as a bow-tied, besuited man of the world, standing upright, holding up his palette and brushes with the certainty of a samurai. Post-Marthe, they become constricted and he even invents a new imprisoned type – the self-portrait in the steamed-up bathroom mirror. Unlike Corinth, but like Ibsen's Professor Rubek, Bonnard is never shown touching his partner or looking at her.

The first paintings of Marthe soaking in her big bath date from 1925, the year of their marriage (see page 6). Marthe was secretive: she had run away from home, changed her name, and pretended her immediate family were dead. She was also reclusive, rarely going out or receiving visitors. They never had children, so for most of the time, it was just them (and a cat). Marthe spent several hours each day soaking in the bath. Hydrotherapy was a recommended treatment for tuberculosis, and she may have suffered from this, though others suggested some nervous disorder. No one knew for certain.

Bathrooms were still a luxury in Europe. So what we see is a privileged technological Eden, a modern equivalent to the Roman baths in the historical fantasies of

Lawrence Alma-Tadema. Bonnard's bathrooms are fashioned from blocks of cool and hot colours, laid down in shimmering patchwork mosaics. Whatever his domestic difficulties, Bonnard clearly luxuriated in the mystery of Marthe's condition and habits. He gives her a remembered, younger body.

Even though Marthe still seems to have been willing to pose naked for Bonnard, the pictures suggest a tense relationship. The white enamelled bath is both a cocoon and sarcophagus. The painter's viewpoint is extremely high and bird's eye, as though Bonnard needs to dominate her – or to show how much she trusts him. Yet the overhead viewpoint might be predatory: Bonnard had painted a faun raping a nymph in 1907, and a red-hot, faun-like self-portrait in 1920.

Bonnard's presence is always felt, but in *Nude in the Bath* (1925) it is glimpsed. The bath rises vertically up the picture plane, with Marthe's inert extended body seemingly upended. Bonnard stands near the foot of the bath, tall and attenuated in a mottled blue silk dressing gown, but all we see of him is a thin side-on sliver, from slippered foot to sleeved forearm. He cannot bring himself to look at his Ophelia. He appears to be drawing a self-portrait in a mirror.

BEYOND THE FACE: MODERN AND CONTEMPORARY SELF-PORTRAITS

IN RETROSPECT, the Mexican serial self-portraitist Frida Kahlo (1907–54) appears as a bridge between early 20th-century masking culture and the late 20th-century obsession with the body of the artist. This, allied to the fact that she is a woman exploring her own identity, is one of the main reasons why she has loomed ever larger in the art world since being 'rediscovered' in the late 1970s and early 1980s. In her work, an expressionless, mask-like face surmounts a body to which many things can and do happen – mostly involving suffering. The face first appears in 1926, and remains little changed or aged thereafter. A good parallel for this radiantly beautiful and virtually shadowless face is that of Queen Elizabeth I, the 'Virgin Queen', in her standardized bejewelled state portraits. Kahlo's face remains the same even when stylized tears are allowed to fall, and even when in 1943 a round hole is opened up in her forehead to reveal a skull and her husband Diego Rivera (frontal lobotomies were introduced in the mid-1930s). Her face is a mask of stoicism and scientific objectivity as well as of repressed feeling.

Rivera and his friends called her 'the great concealer'. The action takes place beyond and especially below the face.

Kahlo's art is aggressively autobiographical, with the main topics being her complicated medical history; her intense, torturous relationship with the muralist Rivera; her childhood and family, particularly her photographer father who was steeped in German Romanticism. She initially trained to be a doctor, and spent a great deal of time being treated by doctors. At the age of six, polio left her right leg lame, and then in 1925 a tram ploughed into the bus in which she was travelling, smashing her pelvis and damaging her spine. She started painting self-portraits while recuperating, with a mirror hung from her four-poster bed. All her life, she suffered chronic pain, and had to have several further operations on her leg and spine. Her right leg was eventually amputated. Through all this, she had a chaotic if exciting love life. She married Rivera twice, and his infidelities – even with her own sister – caused more anguish. Because of her damaged pelvis, she was unable to give birth and had several miscarriages. But it was only after her marriage in 1929 that her painting came of age, and was exhibited and sold.

Kahlo said little about her work, but in a letter of 1939 she made her self-portraits sound straightforwardly self-expressive, painted from deep inside: they were 'the most sincere and real thing that I could do to express how I felt about myself and what was in front of me'.[51] Yet what gives her best work its impact is not its transparency, but its intricate play of polarities – between face and body, female and male, European and Mexican.

The Two Fridas (1939), painted during her divorce, shows two mirror-image versions of the artist sitting on a bench, with a stormy backdrop. One wears Mexican, the other European, clothes. Kahlo owned vast quantities of clothes and jewelry, some of it Pre-Columbian, and three hundred garments remain in the last house she shared with Rivera, now a museum. Apparently Rivera preferred the 'Mexican' Frida, and the Mexican one holds his portrait miniature. Frida's heart is exposed – twice over. A vein passes from the portrait miniature, elegantly winds round the 'Mexican's' left arm in the style of Elizabethan jewelry, before entering her heart; another vein passes like an intercontinental telephone cable from her heart across to that of 'European' Frida. They do not simply rely on communication through the tongue or eyes. Euro-Frida's heart is cut open to reveal a cross-section and the vein that trails down her arm is severed. She holds up the cut end with forceps, and lets blood drip into the lap of her white dress. It is a variation on the mystical Catholic cult of the Sacred Heart of Jesus, which was inspired by a female mystic's vision in which Christ held out his own heart to her. But here their hearts are offered to each other.

We may see Kahlo's vitals, but even here there is nothing convulsive or out of control. She is doctor as well as patient. The blood flow is being managed. Her body is filtered through the cool medical eye. The hearts are in no way individualized. They are textbook illustrations. This conjoined body is a machine for living in. The Dadaists had popularized the idea of the mechanized body,

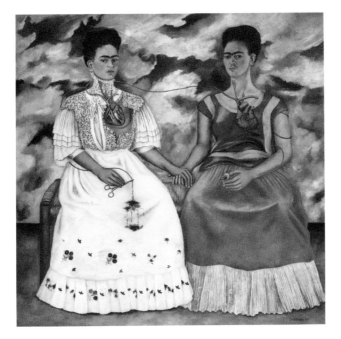

21. Frida Kahlo, *The Two Fridas*, 1939. Oil on canvas.

JAMES HALL

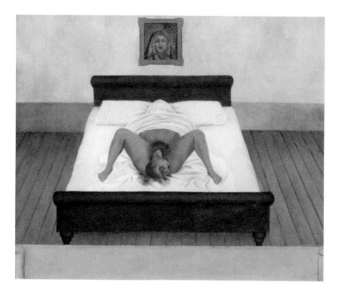

22. Frida Kahlo, *My Birth*, 1932. Oil on metal.

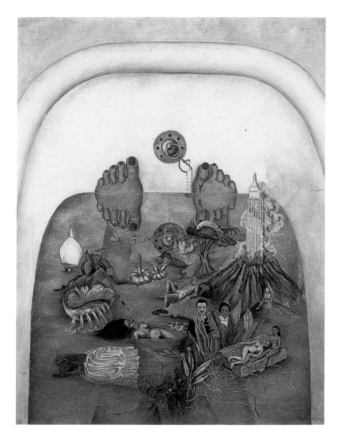

23. Frida Kahlo, *What I Saw in the Water*, 1938.
Oil on canvas.

but it is Kahlo who imbues the idea with pathos. The over-riding feeling of *The Two Fridas* is of solidarity, stoicism and of transfusion.

The potentially destructive and overwhelming aspects of female biological functions are explored in *My Birth* (1932), one of a series of childhood self-portraits, where her mother's upper body is shrouded in a Magrittean white sheet as she gives birth to a daughter in a desolate empty room. This is one of her bleakest works. Another 'decapitating' work, *What I Saw in the Water* (1938), is more exuberant. Here Kahlo is upstaged by her own feet in a bird's-eye view of the plug end of a bath. Her toes project above the water, casting solid reflections. Her right foot had just been operated on, and a long bloody scar travels down from the big toe. The foot is damaged (from childhood polio) and blood drips onto it from two capillaries projecting mysteriously from the overflow. Blood-red nail varnish on the toes completes the raw yet exotic effect.

Here Kahlo recasts the Narcissus myth. It is her toes, rather than her face, that are reflected in the water. Floating around like so many bath toys are miniature islands of incident, mostly over her right leg, where a bird is impaled on a tree, and a skyscraper plunges into the mouth of a volcano. Over Kahlo's right knee, her parents pop up from behind some leaves, cardboard cut-out figures in a Douanier Rousseau jungle (another self-taught artist). She looks down into the water, and finds an almost Proustian flow of memories and dreams.

*

In the 1990s two very different artists, Jeff Koons (b. 1955) and Tracey Emin (b. 1963), made declamatory self-portraiture in which all masks and taboos were supposedly off. Their work, in its stridency and biographical explicitness, marked the climax of the post-1960 exploration of the body and image of the artist.

In 1990, Koons announced in an interview:

> My art and my life are totally one...I have my platform,
> I have the attention, and my voice can be heard. This
> is the time for Jeff Koons.[52]

His work of the early 1980s had not involved self-portraiture, but had celebrated and mocked consumer commodity fetishism, starting with brand-new Hoovers exhibited in Perspex display cases. He moved on to luridly coloured, life-sized porcelain sculptures of celebrities, such as *Michael Jackson and Bubbles* (1988). From 1989–91, in a series called *Made in Heaven*, we saw a naked adult Koons in action again and again, with Italian porn star Ilona Staller (La Cicciolina). *Made in Heaven* was a multimedia extravaganza consisting of hyperreal posters, photo-paintings and sculptures (glass, marble, polychrome wood and plastic). The happy and athletic couple, both perfect and sweatless specimens, are a new Raphael and La Fornarina. They explore what Milton, in *Paradise Lost*, termed 'the Rites mysterious of connubial love' (they had a spectacular wedding in 1991, a son in 1992, and parted soon after). *Made in Heaven* garnered oceans of publicity but – for obvious reasons – did not sell as well as previous work.

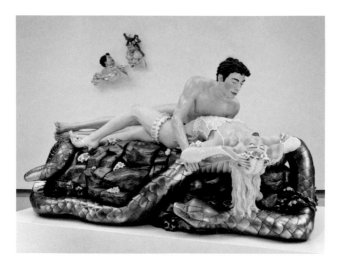

24. Jeff Koons, *Jeff and Ilona (Made in Heaven)*,
1990. Polychromed wood.

Koons was evidently challenging the pained pieties of so much modern 'body' art, whereby the body tended to be fragmented, damaged (often literally and dangerously) and/or masked. Even the self-portraits of Koons's biggest artistic forebear in embracing mass culture, Andy Warhol, made sporadically throughout his career, tend to be fidgety exercises in neurotic concealment. But this studied awkwardness is true too of earlier male artists who have depicted themselves with wives and mistresses: Munch, Corinth and Bonnard were not exactly brimful with joy. So Koons is, at the very least, doing something new: he's a monogamous bacchanalian artist selling a perfect lifestyle, with all the slick urbanity of Ralph Lauren.

The photo-paintings are just too literal-minded – and pornographic – to be interesting. The sculptures are far more impressive because of their greater levels of abstraction and self-containment. *Jeff and Ilona* (1990), a huge polychromed limewood sculpture nearly 3 metres long and over 1.6 metres wide, was first displayed at the Venice Biennale surrounded by garish photo pieces. In that context, one could see it in the tradition of the Venetian 'al fresco' reclining nude, with Jeff leaning over a swooning Ilona. They lay on a dark rocky 'bed', surrounded and seemingly protected by a giant gilded serpent. It was carved and painted by German craftsmen. But it is not viscerally sensuous or sinuous, in the manner of Rodin's *The Kiss*. The sex is mostly staged on hard and/or abrasive surfaces. The glass versions are like ice floes, and one of the white marble busts even sprouts crystals. It is a rewriting of the Pygmalion myth. Instead of Galatea stepping

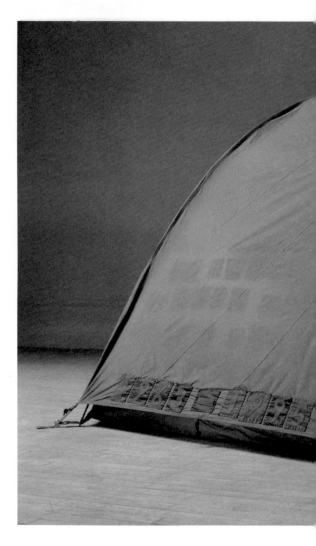

25. Tracey Emin, *Everyone I Have Ever Slept With 1963–95*, 1995. Appliquéd tent, mattress and light (destroyed 2004).

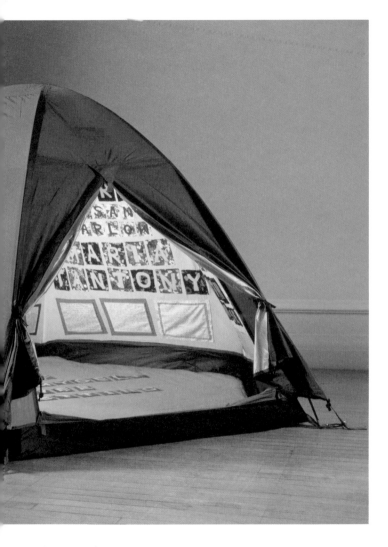

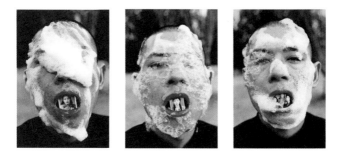

26. Zhang Huan, *Foam*, 1998. Performance
photographs.

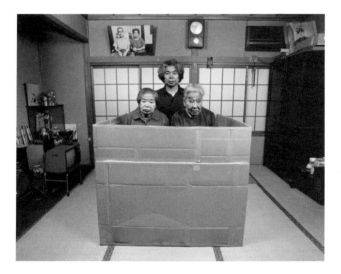

27. Tatsumi Orimoto, *Art Mama: In the Box*,
series 1997–2007. Colour photograph.

off her pedestal and coming to warm transitory life, Pygmalion has climbed onto Galatea's pedestal to share her sterilely statuesque utopia.

The British artist Tracey Emin is in many ways the archetypal modern career self-portraitist. She is self-conscious to a fault, almost from the start treating herself as a historical figure, curating the bad, mostly sexual-medical bits of her own life, half wanting what the psychologists would call 'closure', but doomed to repeat her mistakes endlessly – in prickly drawings, text-laden embroideries and garrulous films. She stalks her past, but even more so than Courbet in his early self-portraits, she is incessantly imagining her own death and her own mausoleum, full of opaque yet moralizing inscriptions that will save the world: 'THE LAST GREAT MOMENT IS LOVE; DON'T DIE JUST KEEP LOVING', etc.

Her first gallery exhibition was entitled 'Tracey Emin: My Major Retrospective 1963–1993', and in 1995 she made her finest work, *Everyone I Have Ever Slept With 1963–95* (destroyed 2004), a blue domed two-person tent – embroidered on the inside with seventy-five names, male and female. It is Emin's mobile Pantheon, Tempio and kinship self-portrait. She did not, however, identify these people as friends or family sharing a bed, lovers or strangers, welcome or unwelcome.

Since the Koons–Emin explosion of the 1990s (and Emin's autobiographical sloganeering continues unabated), there has been an understandable lull in the production of self-portraits by gallery artists. The Chinese artist Zhang Huan (b. 1965) is a case in point. He made

his name with militant initiation/endurance nude performances with shaved head; these had photographic and sculptural residues. But in 2005 he gave up performance and started to produce giant paintings made from ash, with little or no self-portrayal.

However, one of Huan's best self-portraits, *Foam* (1998), may be a pointer to a future direction in self-portraiture. In a series of photographs of his foam-covered head, Huan's mouth is open to reveal family photographs, old and new, stuffed between lips and teeth. He is like a drowning man whose whole life passes before him, but in this case he only retains his memories of his family.

The artist as 'family man' also appears in the work of Japanese Performance artist Tatsumi Orimoto (b. 1946). When his mother, who had always supported and subsidized his career in art, was diagnosed with Alzheimer's, he moved into her flat to look after her, and incorporated her into his absurdist yet moving *Art Mama* performances. They stand together in Beckettian oil drums, or in a cardboard box shared with a neighbour; he holds and hugs her, pushes her wheelchair. The citizens of Nuremberg, who displayed Dürer's self-portrait next to his portrait of his elderly mother, might have understood if not quite approved.

NOTES

1 For a survey of these issues, S. Perkinson, *The Likeness of the King: A Prehistory of Portraiture in Late Medieval France*, Chicago, 2009; J.-C. Bonne, 'L'Image de soi au Moyen Âge (IXe–XIIe siècles)...', in *Il ritratto e la memoria*, vol. 2, ed. A. Gentili et al., Rome, 1993, pp. 37–60; H. L. Kessler, *Seeing Medieval Art*, Toronto, 2004, p. 33ff.

2 Plotinus, *The Enneads*, trans. S. MacKenna, London, 1991, I: 6.9.

3 Theophilus, *On Diverse Arts*, ed., trans. C. R. Dodwell, Edinburgh, p. 14ff.

4 M. Camille, *Image on the Edge: The Margins of Medieval Art*, London, 1992, pp. 24–6.

5 R. W. Gaston, 'Attention and Inattention in Religious Painting of the Renaissance', in *Renaissance Studies in Honour of Craig Hugh Smyth*, vol. 2, ed. A. Morrogh et al., Florence, 1985, p. 256.

6 Augustine, *The Confessions*, trans. P. Burton, London, 2001, p. 250, bk 10: 35.57.

7 R. Brandl, 'Art or Craft?: Art and the Artist in Medieval Nuremberg', in *Gothic and Renaissance Art in Nuremberg*, New York, 1986, p. 51ff.

8 M. Rogers, 'The Artist as Beauty', in *Concepts of Beauty in Renaissance Art*, ed. F. Ames-Lewis and M. Rogers, Aldershot, 1998, pp. 93–106.

9 W. M. Conway, ed. and trans., *The Writings of Albrecht Dürer*, New York, 1958, pp. 53, 57–8.

10 Ibid., pp. 48–9.

11 W. Stechow, ed., *Northern Renaissance Art 1400–1600*, Evanston, 1989, p. 112.

12 J. L. Koerner, *The Moment of Self-Portraiture in German Renaissance Art*, Chicago, 1993, p. 70.

13 R. Kahsnitz cat. entry, *Gothic and Renaissance Art in Nuremberg*, p. 130.

14 J. Cage, ed. and trans., *Goethe on Art*, London, 1980, p. 137.

15 For the studio, S. Alpers, *Rembrandt's Enterprise*, Chicago, 1988; and S. Alpers, *The Vexations of Art*, New Haven, 2005.

16 K. Christiansen and J. W. Mann, eds, *Orazio and Artemisia Gentileschi*, New York, 2001, p. 322.

17 M. Garrard, *Artemisia Gentileschi*, Princeton, 1989, pp. 141–71.

18 Christiansen and Mann, eds, *Orazio and Artemisia*, p. 420.

19 Ibid., p. 417.

20 R. M. Smuts, *Court Culture and the Origins of a Royalist Tradition in Early Stuart England*, Philadelphia, 1987, p. 122.

21 O. Millar, 'Abraham van der Doort's Catalogue of the Collections of Charles I', *The Walpole Society*, 37, 1958–60. See also F. Haskell, 'Charles I's Collection of Pictures', in *The Late King's Goods*, ed. A. MacGregor, London, 1989, pp. 203–31.

22 Christiansen and Mann, eds, *Orazio and Artemisia*, p. 418; C. Ripa, *Iconologia*, ed. P. Buscaroli, Milan, 1992, p. 357.

23 J. Hall, 'Look of Self Love', *Times Literary Supplement*, 6 January 2006.

24 Michelangelo, *The Poems*, trans. C. Ryan, London, 1996, no. 235, p. 191.

25 Letter 515. References are to the letter numbers in http://vangoghletters.org/vg/letters.html; 26 Letter 288; 27 Letter 495; 28 Letter 811; 29 Letter 547; 30 See letter 681.

31 For Rembrandt self-portrait, see letter 649.

32 C. Vosmaer, *Rembrandt: Sa vie et ses œuvres*, La Haye, 1877, p. 20.

33 C. Gere with L. Hoskins, *The House Beautiful: Oscar Wilde and the Aesthetic Interior*, Aldershot, 2000, p. 28.

34 Letter 677.

35 Letter 515.

36 Manet appears in *Music at the Tuileries*, included in the show.

37 *Wilhelm Wackenroder's Confessions and Fantasies*, trans. M. H. Schubert, University Park, PA, 1971, pp. 81–2, 108–15.

38 Letter 719.

39 Letter 704.

40 Ernest Ponthier de Chamillard. Letter 698.

41 Letter 677.

42 D. W. Druick and B. Salvesen, *Van Gogh and Gauguin: The Studio of the South*, London, 2001, p. 210.

43 Letter 800.

44 J. Lethève, *Daily Life of French Artists in the Nineteenth Century*, London, 1972, pp. 185–6.

45 I. Müller-Westermann, *Munch by Himself*, London, 2005, pp. 26–33, cat. nos 4, 5, 10, 11.

46 D. Ades, 'Duchamp's masquerades', in *The Portrait in Photography*, ed. G. Clarke, London, 1992, pp. 94–114.

47 C. Berend-Corinth, *Die Gemälde von Lovis Corinth*, Munich, 1958.

48 B. Uhde-Stahl, *Paula Modersohn-Becker*, Stuttgart, 1989, p. 100.

49 S. Whitfield, *Bonnard*, London, 1998, pp. 9–10.

50 N. Watkins, *Bonnard*, London, 1994, pp. 11–14.

51 Letter to Carlos Chavez, 1939. *The Letters of Frida Kahlo*, ed. M. Zamora, San Francisco, 1995, pp. 104–5.

52 *The Jeff Koons Handbook*, London, 1992, p. 120.

LIST OF ILLUSTRATIONS

Measurements are given height before width, cm followed by inches

1. Pierre Bonnard, *Nude in the Bath,* 1925, oil on canvas, 104.8 × 65.4 (40½ × 25¼). Tate. **2.** Leon Battista Alberti, *Self-Portrait, c.* 1435, bronze plaquette, (irregular oval) 20.1 × 13.6 (7⅞ × 5⅜). National Gallery of Art, Washington. Samuel H. Kress Collection (1957.14.125). **3.** Rembrandt, *Self-Portrait, c.* 1665, oil on canvas, 114.3 × 94 (45 × 37). Kenwood House, London. **4.** Titian, *Self-Portrait,* 1560s, oil on canvas, 86 × 65 (33⅞ × 25⅝). Museo Nacional del Prado, Madrid. **5.** Diego Velázquez, *Las Meninas,* 1656, oil on canvas, 318 × 276 (125¼ × 108⅝). Museo Nacional del Prado, Madrid. **6.** Saint Dunstan, *Self-Portrait Worshipping Christ, c.* 943–57, ink on parchment. Bodleian Library, Oxford (Ms. Auct. F. 4. 32, f.1). **7.** Hildebertus, *Self-Portrait with His Assistant Everwinus, c.* 1150, ink on parchment. Metropolitan Library, Prague (A. XXI/1, f. 153v). **8.** Albrecht Dürer, *Self-Portrait,* 1498, oil on panel, 52 × 41 (20½ × 16⅛). Museo Nacional del Prado, Madrid. **9.** Albrecht Dürer, *Self-Portrait,* 1500, oil on panel, 66.3 × 49 (26⅛ × 19¼). Alte Pinakothek Muenchen - Bayerische Staatsgemaeldesammlungen, Munich. **10.** Albrecht Dürer, *Sudarium of St Veronica; two angels holding the cloth depicting the face of Christ,* 1513, engraving, 10 × 13.8 (4 × 5½). Metropolitan Museum of Art, New York. Gift of Henry Walters, 1917 (17.37.112). **11.** Artemisia Gentileschi, *Judith Slaying Holofernes, c.* 1612–13, oil on canvas, 146.5 × 108 (57¾ × 42⅝). Uffizi, Florence. **12.** Artemisia Gentileschi, *Self-Portrait as the Allegory of Painting, c.* 1638–9, oil on canvas, 98.6 × 75.2 (38⅞ × 29⅝). Royal Collection Trust / © His Majesty King Charles III, 2024 / Bridgeman Images. **13.** Rembrandt, *Self-Portrait at the Easel,* 1660, oil on canvas, 111 × 90 (43¾ × 35½). Musée du Louvre, Paris. **14.** Vincent van Gogh, *Self-Portrait at the Easel,* winter 1887–8, oil on canvas, 65 × 50.5 (25⅝ × 19⅞). Van Gogh Museum, Amsterdam (Vincent van Gogh Foundation). **15.** Vincent van Gogh, *Van Gogh's Chair,* 1888, oil on canvas, 93 × 73.5 (36⅝ × 28⅞). National Gallery, London. **16.** Vincent van Gogh, *Gauguin's Chair,* 1888, oil on canvas, 90.5 × 72 (35⅝ × 28⅜). Van Gogh Museum, Amsterdam (Vincent van Gogh Foundation). **17.** Paul Gauguin, *Self-Portrait with Portrait of Émile Bernard,* 1888, oil on canvas, 44.5 × 50.3 (17⅝ × 19⅞). Van Gogh Museum, Amsterdam (Vincent van Gogh Foundation). **18.** Vincent van Gogh, *Self-Portrait with Bandaged Ear,* 1889, oil on canvas, 60.5 × 50 (23⅞ × 19¾). The Courtauld,

London (Samuel Courtauld Trust). **19.** Edvard Munch, *Self-Portrait in Hell*, 1903, oil on canvas, 81.6 × 65.6 (32⅛ × 25⅞). Munch Museum, Oslo. **20.** Paula Modersohn-Becker, *Self-Portrait*, 1906, oil on card, 101.5 × 70.2 (40 × 27⅝). Kunstsammlungen Böttcherstrasse/Paula-Modersohn-Becker-Museum, Bremen. **21.** Frida Kahlo, *The Two Fridas*, 1939, oil on canvas, 172.7 × 172.7 (68 × 68). Museo de Arte Moderna, Mexico City. © Banco de México Diego Rivera Frida Kahlo Museums Trust, Mexico, D.F./DACS 2024. **22.** Frida Kahlo, *My Birth*, 1932, oil on metal, 30.5 × 35.6 (12 × 14). Private collection, USA. © Banco de México Diego Rivera Frida Kahlo Museums Trust, Mexico, D.F./DACS 2024. **23.** Frida Kahlo, *What I Saw in the Water*, 1938, oil on canvas, 91 × 70.5 (35⅞ × 27¾). Private collection. © Banco de México Diego Rivera Frida Kahlo Museums Trust, Mexico, D.F./DACS 2024. **24.** Jeff Koons, *Jeff and Ilona (Made in Heaven)*, 1990, polychromed wood, 167.6 × 289.6 × 162.6 (66 × 114 × 64) Edition of 3 plus AP. © Jeff Koons. **25.** Tracey Emin, *Everyone I Have Ever Slept With 1963–95*, 1995 (destroyed 2004), appliquéd tent, mattress and light, 122 × 245 × 215 (48 × 96½ × 84½). Photo Stephen White. Courtesy White Cube. © Tracey Emin. All rights reserved, DACS 2024. **26.** Zhang Huan, *Foam*, 1998, performance photographs. Courtesy the artist and Pace Gallery. © Zhang Huan. **27.** Tatsumi Orimoto, *Art Mama: In the Box*, series 1997–2007, colour photograph, 60.5 × 75.6 (23⅞ × 29¾). Series of 3. Edition of 20. Courtesy DNA, Berlin. © Tatsumi Orimoto.

Be the first to know about our new releases,
exclusive content and author events by visiting
thamesandhudson.com
thamesandhudsonusa.com
thamesandhudson.com.au

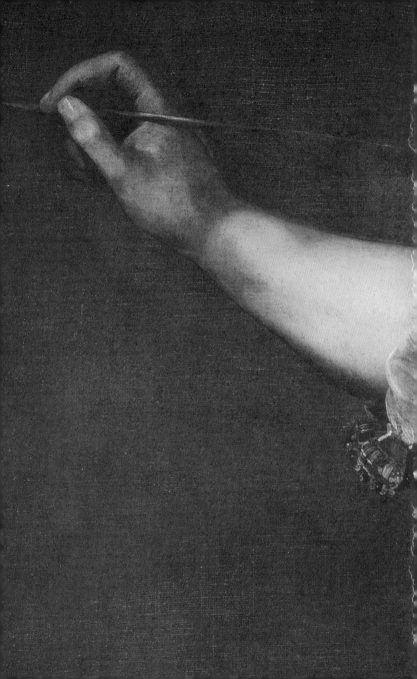